ARTISTIC CRAFTS
INVENTIVE CREATIONS FROM CAST-OFFS

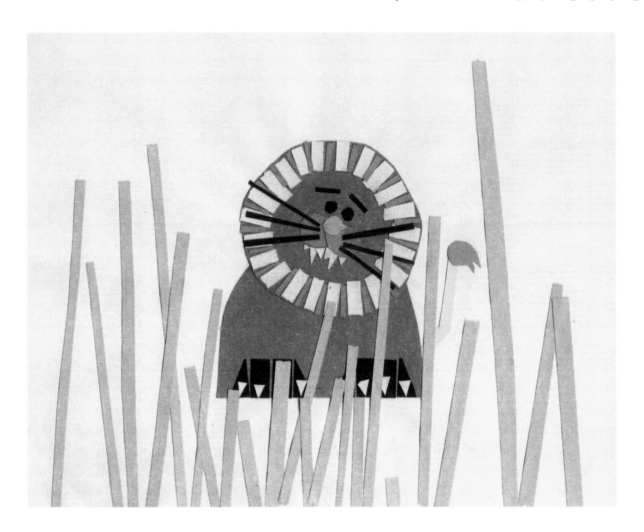

JUDITH PECK

IMAGINATION ARTS PUBLICATIONS

Using the materials and processes that Dr. Peck presents in her book, teachers can maintain the integrity of their art programs on limited budgets while simultaneously giving life to worn and weary treasures. I recommend Artistic Crafts for parents and children as well as art educators. The numerous illustrations of colorful works produced by Judith's students will inspire creativity in artists of all ages.

Kim L. Defibaugh, Ed.D., Supervisor of Visual and Performing Arts
Toms River Regional Schools

Other Books by Judith Peck

Leap to the Sun: Learning through Dynamic Play

Art & Interaction: A Fieldwork Program for Colleges
An Activities Program for Institutions

Sculpture as Experience: Working with Clay, Wire, Wax,
Plaster and Found Objects

Art Activities for Mind and Imagination

Dr. Judith Picture Books

Smart Starts in the Arts: Fostering Intelligence, Creativity,
and Serenity in the Early Years

For information on Judith Peck's sculpture and books
visit www.judithpeck.com

To Order:
Imagination Arts Publications
P.O. Box 103
Mahwah, NJ 07430-0103
Or securely on line:
www.iapbooks.com
E-Mail: iapbooks@optonline.net

TABLE OF CONTENTS

ACKNOWLEDGMENTS

Students of the School of Contemporary Arts at Ramapo College of New Jersey are a remarkably creative lot. All of the illustrations of art work in this text are by students enrolled in the college/community field work course, Art & Interaction, formerly called Art on the Outside. Because I developed this course thirty years ago and have taught it ever since, a large body of art work has been produced. Although students in years long gone described their work for me on paper and gave permission to use it if ever I wanted to include it in a book, some of the written descriptions are unidentifiable in relation to the art photographed. Enormous effort was expended in trying to correspond description to illustration to student name for the purposes of this text, but unfortunately, some very lovely projects must remain unidentified. I remain immensely grateful for the energy, enthusiasm and unique creativity of my students. Their personalities as well as their efforts and talents are expressed in the art work they produced. Indeed, art has a way of doing just that.

I am grateful to the administration of Ramapo College and to my colleagues in the School of Contemporary Arts for the faith they demonstrated in the Art and Interaction program, such that it has been supported for all these years. The program trains undergraduates to present spontaneous art projects in combination with social interaction to the youth, residents, patients, clientele and detainees in a variety of facilities: homes for abused children, after school programs in urban housing projects, veterans centers, nursing homes, psychiatric centers, battered women's shelters, adult day care centers and jails. The vibrant color and texture of the students' art is perhaps testimony to the rich experiences they have encountered, sharing creative inspiration with people they would not otherwise have encountered.

— Judith Peck

INTRODUCTION

COLLECTING CAST-OFFS

What to do with the crisp, clean, guillotined borders of paper goods discarded by the graphics department of your school or workplace, those perfectly fine orphans of a measurement?

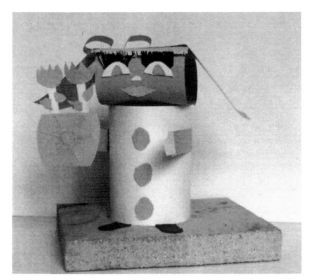

SP-7: Figure with Flowers, strip-paper sculpture

What about the ripped old clothes the Salvation Army won't have: skirts and shirts and sweaters that hold idyllic memories of a slimmer you, of who you wore them with and when and where?
Or the curtains you bought for your first apartment, now too small, too cute, too whatever? Tossing memories out as trash seems almost disrespectful.

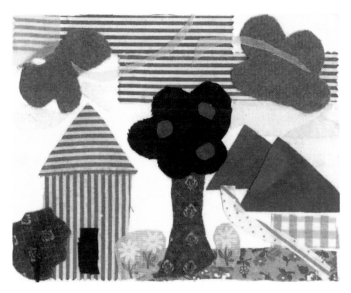

SF-4: House and Garden with Apple Tree, fabric collage

So why not give another life to those worn and weary treasures that served industry and you so well? And while you are thinking of rescue, what about wallpaper leftovers: the extra roll the salesman insisted you buy, so the dye lots would match if you ran out midway up the wall?

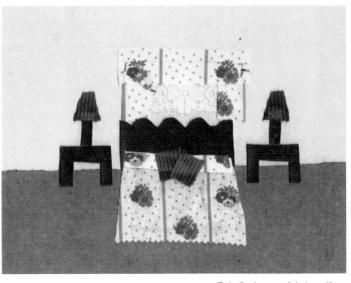

F-6: Bedroom, fabric collage

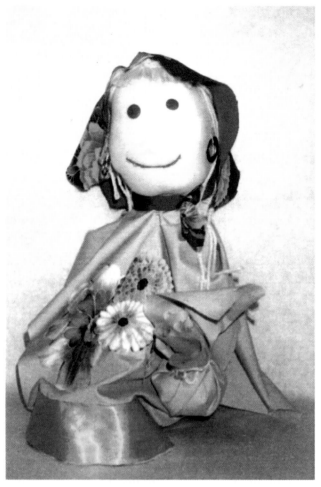

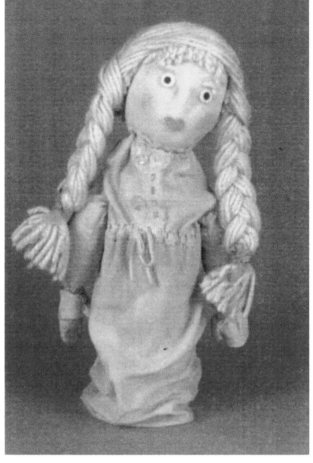

P-4: Pretty Lady, puppet:

P-5: Little Girl with Braids, puppet

You don't mind discarding a toilet paper roll; its purpose was served and another installed already. But what a nice shape the roll is and sturdy too, solid enough to hold its shape; a surface easily glued and stapled to plus an opening just right for a hand to slip into. You couldn't find a better armature for a puppet.

Then, there are all those buttons popped off shirts and skirts, and buttons on the clothes that have no use and the buttons your grandma kept in a cigar box. And what about the former residents of that box, the empty plastic tubes holding the cigars? Too solid to toss out but perfect for finger puppets. And then there's the wool left over from the afghan your Aunt made.

So this book is a rescue effort of sorts, offering paper and fabric and wallpaper and toilet paper tubes and buttons and wool a second chance to BE somebody. And you can be somebody too. An artist. Because just as these cast-offs have color and pattern and texture and vitality of their own, so do you, for you bring to this artistry your personal attributes. Begin by collecting some materials; you will master the techniques as you go along.

ARTISTRY IN CRAFTS

The crafts described in the text are all designed with aesthetics in mind. This means being mindful of the artistic elements that comprise each project. Although the product is a work of craft, the process uses all the elements of art making. What you bring to this task are similar to what artists bring to their various disciplines of drawing, painting and sculpture: not the techniques but the sensitivities.

Attributes of the Artist

- Alert powers of perception
- Aesthetic awareness of shape, color, texture, rhythm, balance and spatial relationships
- Emotional sensitivity and the ability to use this in artistic production
- Imaginative ideas
- Perseverance
- Control (of both materials and frustration)
- Confidence in one's own potential abilities

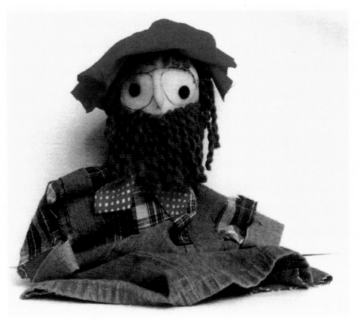

P-6: Philosopher, puppet

AESTHETIC ELEMENTS: A CONCISE VOCABULARY

Here is a simplified summarization of some of the aesthetic elements you might want to refer back to as you proceed. Think of this as an aesthetic vocabulary which you carry in your mind, just as you carry key word translations when you go on a foreign trip. Are you considering any of these elements as you create your project? If you incorporate any of these elements in your project, will it be more interesting?

- *Form*: consistency of form; variations of form
- *Shapes*: predominantly geometric or predominantly organic (meaning forms seen in the body and in nature)
- *Style*: such as abstract, semi-abstract, representational
- *Structure*: a sense of solidity; planes
- *Spatial composition*: how forms fill a given space
- *Light and shadow*
- *Texture*
- *Line*: vertical, horizontal, diagonal, curvilinear
- *Pattern and design*
- *Rhythm*
- *Balance*
- *Perspective*
- *Contrast*: in line, texture, light and shadow, balance

Of course, you will not use all of these elements in your projects, nor might you even be aware of them as you start out, but referring to the list as you go along might give you ideas for improvement. **How many elements, for instance, are incorporated in this acrylic painting on a plaster plate DP-5?**

Form: The hard edges containing the forms in this portrait make for consistency in the overall picture, but there are several variations of form as well: the ovals of the hair, the rectangular neck, the circular background.

Style: The style is representative — a profile is clearly seen — but in its simplification of forms and elaborate abstraction of hair and flowers, it might be seen as semi-abstract.

Structure: The solidity of the supporting neck in both form and solid color provides a sense of structure for the curvilinear and colorful elaboration of the hair and flowers.

Spatial composition: The dark edges surrounding the head set off the colorful interior of the profile. The face, looking out, is not cramped; instead a wider area of black exists at that end.

Line: The diagonal line of the neck rising to the thin semi-circular line of the chin gives the face a dynamic thrust forward. The gently curving lines are repeated in the brow and eyelid, and wider and more strongly all through the waves of the hair.

Pattern and Design: Decoratively designed, the patterns in the hair are thin black lines filled in with color; the colors red, purple and yellow are repeated in various patterns throughout the hair, broken up with a large red flower bud supported by green leaves.

Rhythm: rhythm is a musical term but it works in art as well. Here, there is the fast but lyrical flow in the pattern of waves; the slow, gentle, sloping line in the profile; and the circular rhythm of the plaster plate on which the profile is painted.

Contrast: Contrast in this portrait exists in the display of brilliant colors against a dark background; the straight line of the neck against the curves of the chin and eyes; the simplicity of the thin profile line against the wide, heavily filled in patterns of the hair.

CONCLUSION

The techniques for working with the materials in each project will vary, of course, and will necessitate different aesthetic responses from you. But a single fundamental approach will run through each project and that is this: the materials will present ideas to you. Let this happen. You may have a vague notion of what you want to make but be prepared that it will change as your ideas connect with the material offerings before you. Actually, that's the fun of it: surprise and invention. Be open, be bold, be adventurous, be artistic. You can afford to be all these things. These vibrant materials are only cast-offs, after all.

Finally, it is certain that you will have other and even perhaps better ideas for using the materials and processes described once you get going. This is as it should be. Think about this as you venture onto each project, remembering that the book is not designed to be a step-by-step prescription but to stimulate you to find projects that appeal because of the distinctive personality and individuality you bring to them.

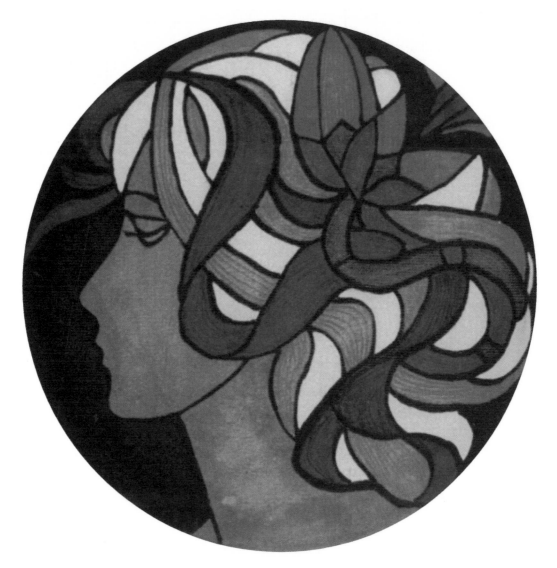

DP-5: Floral Portrait, acrylic painting on plaster plate

1 STRIP PAPER DESIGNS

TWO-DIMENSIONAL PICTURES

Description

Colored paper strips are often available in large supply and in multiple colors from the graphics department of schools and offices in the form of trimmed scraps from work orders. These trimmings can be used to create 2-dimensional wall collages or 3-dimensional sculptures mounted on bases. The variety of widths in the trimmings is the basis for both projects.

Let the various widths generate pictorial themes. For example, strips placed horizontally resemble wood siding, making the exterior of a house or apartment and its surroundings work well as a theme. Remember that the picture should be an artistic interpretation of the house, not a rendering or a likeness, and it can be as fanciful as one wishes.

Suggested Materials

- Paper strips in assorted sizes and colors
- Oak tag, poster board, or construction paper
- Glue stick or white glue
- Scissors
- Paper towels
- Optional: plastic laminate or standard frame

Process

1. Use the paper strips as they are or cut or tear them. The limitation of using the widths as you find them can actually stimulate rather than deter your creative thinking.

2. Overlap strips in places or tear them to make irregular or frayed edges.

3. Glue the strips according to your design onto oak tag or construction paper.

4. Add whatever lines you wish in pencil or ink; however, don't obscure the simplicity of the geometric shapes with too much mixed media.

5. Alternatively, cut colored strips in whatever shape you like and paste them on a colored background. Try for consistency in style, whether you use geometric shapes, flower shapes, or any other manner of shapes and strips.

6. Optional: If you want to frame the picture, choose a background of construction paper in a color to set off the picture. Apply a plastic laminate to the whole and hang with press-on hooks; or insert the picture in a standard frame.

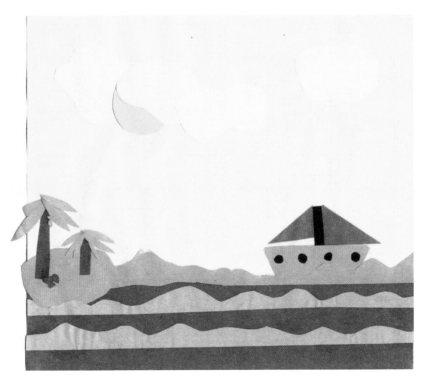

SP-1: Sailboat and Palm Trees

SP-2 Elegant House

SP-3 Stately House

11

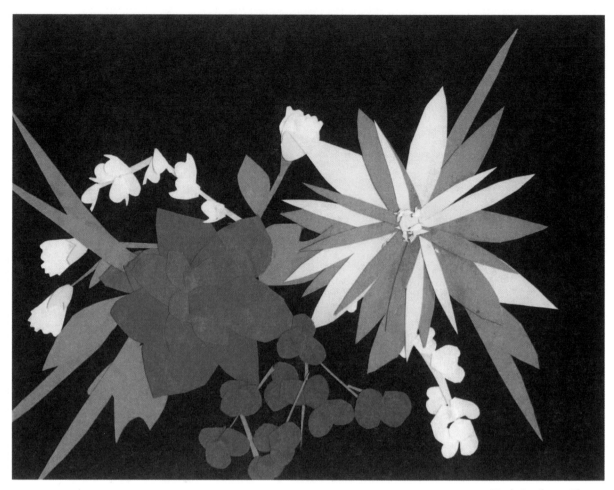

SP-4 Sunburst Flowers

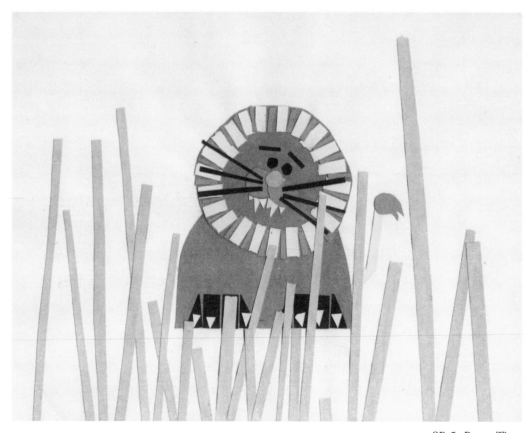

SP-5: Paper Tiger

12

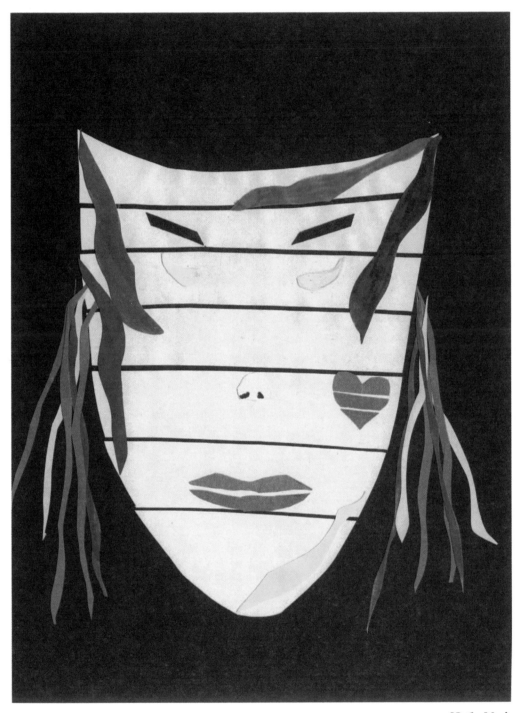

SP-6: Mask

THREE-DIMENSIONAL OBJECTS

Description:

The major difference between the Strip Paper Design project and Strip Paper 3-D Sculptures is that the latter are free-standing and seen in the round. The same principles of design simplicity and using the limitation of cut shapes applies. It's a good idea to make the part that has to stand up in cardboard rather than paper for stability. Other than getting the piece to stand and adding a wood base for mounting, the process is the same. You begin the project in the same manner as in 2-D Strip Paper design, assembling strips and gluing them onto colored paper.

Suggested Materials

- All materials listed on page 10
- Wooden base for mounting
- Stapler
- Masking tape

Process

1. Follow the processes listed in Two-dimensional Pictures, page 10.

2. Bend the finished forms into 3-dimensional shapes to form an object; make sure the piece works visually from all sides.

3. Prepare a base by finding or cutting the right size for the piece. About one-inch open space all around the sculpture is a good benchmark for the sides, front and back. A depth of about one inch will usually be right too, not so deep that it takes on more importance than the sculpture. A base is meant to show off the sculpture and separate it from its surroundings, not overwhelm it by being too wide, deep or thick.

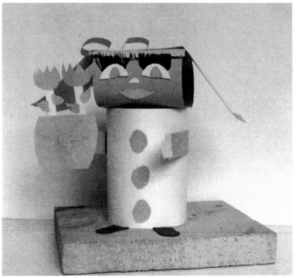

4. Mount the object with stapler or glue onto a base that has been sanded; the base can be painted but again, should enhance rather than compete with the sculptural object.

SP-7: Figure with Flowers, 3-D strip sculpture

2 MOVABLES

MOVABLE FIGURES, ANIMALS AND OBJECTS

Description

"Movables" are shapes cut from colored construction paper. Brass fasteners are attached in such a way that the shapes you want to move can move. The project lends itself to clever representation of people, animals, vehicles, bugs, flowers and any manner of artifacts.

Just about everything moves. As you manipulate the cardboard and the fasteners, ideas for designing movement will pop into your head. In addition to drawing, you might cut pictures from magazines and coordinate parts of these onto cardboard for your movable. Photographs of people or places can be a source of amusing or clever ideas. Drawing on paper first might help you begin. The illustrations supplied here should give you sufficient ideas to start off. Remember that aesthetics counts in this project as in all others, however "crafty."

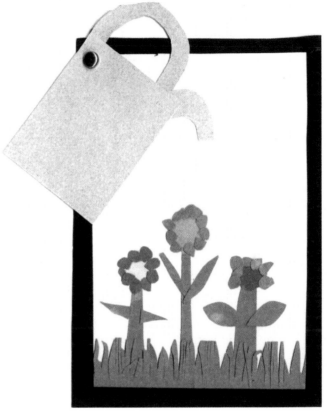

M-1: Watering Can

Suggested Materials

- Cardboard, oak tag or poster board
- Colored construction paper
- White glue or glue stick
- Pencil
- Colored markers
- Brass fasteners
- Optional: magazines or photographs

Process

1. Using colored construction paper, cut out the full shape of your subject.

2. Cut off the parts intended to move.

3. Note: depending on the complexity of your movable, all shapes, stationary and moving, might need to be cut out separately.

4. If additional sturdiness is needed, glue the paper onto cardboard backing.

5. Attach the movable parts with brass fasteners to the main body of your figure, animal or object. Use the pin of the fastener or any sharp point to push through the points of the fastener.

6. Consider adding drawing, colored markers or magazine collage to embellish the image.

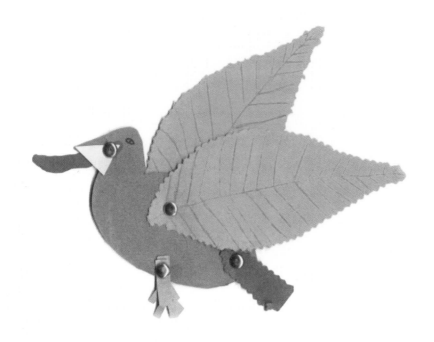

M-2: Flying Bird

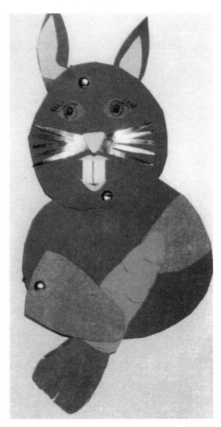

M-7: Rabbit with Carrot

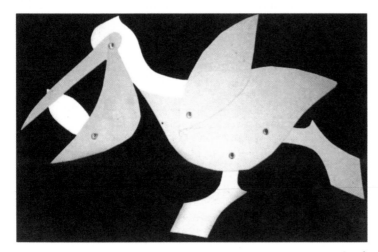

M-3: Stork

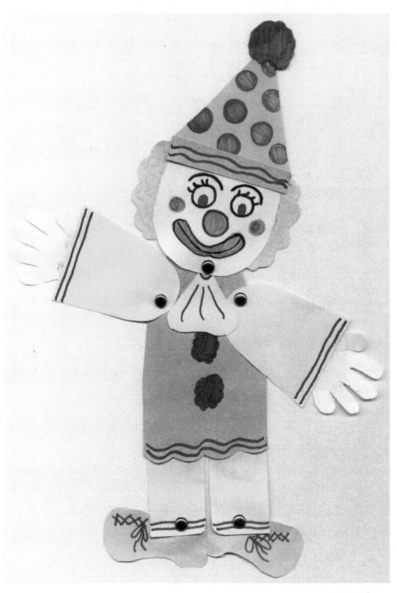

M-6: Clown

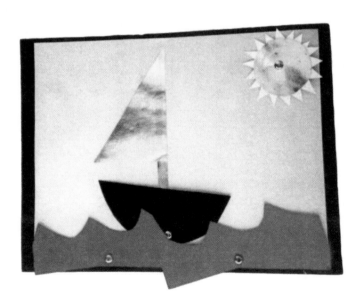

M-4: Stormy Sea

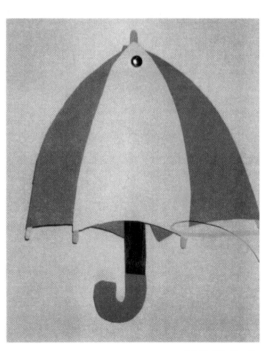

M-5: Umbrella

MOVABLE GREETING CARDS

Description:

The movable project can be put into service to convey uniquely individual greetings. Whether your greeting refers to an avocation, a vocation, recreation, foible, sport, job or charming mannerism, the movable, with words added, can be tucked into an envelope to deliver a message fondly and humorously. Call on characteristics of the recipient that you know or observe: someone who lives by the clock; drives a lot; reminds you of a certain animal; loves nature; clowns around. Be prepared to get one back. Be kind.

It's advisable to keep the design of the card simple because you might want to reproduce it with variations to send to others, adding or eliminating depending on its destination and purpose.

See "Movable Figures, Animals and Objects," pages 15-17 for suggested materials and process. Here are some suggestions for reproducing movable greeting cards, although you will no doubt find your own ways:

1. You can simply cut, paste, copy and add note, following procedures 5-9 below, or:

2. Scan the colored image and send it to your computer, saved as a jpeg file.

3. Type text for a message and save, ready to be altered here and there for separate recipients.

4. Print both files.

5. Make multiple copies of the image. (If size allows, copy and paste an image two or three times on the same page to save excessive page copying.)

 - Use construction paper if possible.
 - Photocopy paper will do but if there are to be several movable parts, you may have to back the image with something firmer.
 - Stationery chains like Staples will copy onto coated stock which is bright white and shiny.
 - Copy onto photo paper for another bright white and shiny result.

6. Cut out the image, separating the parts that will move.

7. Connect the parts with brass fasteners.

8. Add your note :

 - Cut and paste it somewhere on the back or front of the movable
 - Or print it onto 8 1/2" x 11" paper and fold it over the movable like a sandwich. Staple the movable at the top so it doesn't fall out.
 - Or staple the movable to half a sheet of paper, already printed with your greeting.

9. Sign, add a personal note if you like, stuff it in an envelope, stamp and dispatch.

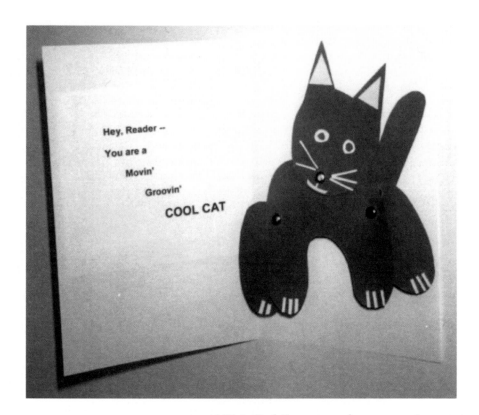

MG-1: Cool Cat, note card on construction paper

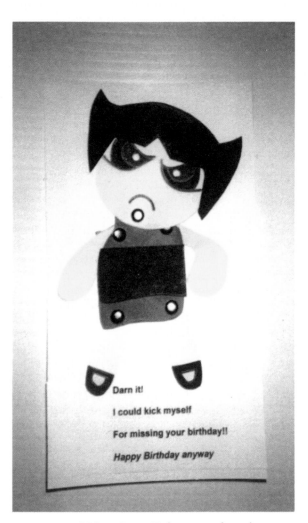

MG-2: Angry Kid, note card on photo paper

MOVABLE CARDBOARD TOYS

Description

A movable made with cardboard can be fun for a child to play with as he or she makes the arms, legs, head and tail of a creature move. Of course, fasteners must be secure and the cardboard stiff enough to last for at least a few dozen manipulations. The project is a good partnership activity between adult and child.

Suggested Materials and Process

See "Movable Figures, Animals and Objects" on pages 15-17.

To "play" with the movable toy:

- Press a small mound of plastiline (oil based clay) into a ball.
- Secure the clay to a surface.
- Press a Popsicle stick or nail into the clay and squeeze the clay around it.
- Attach the other end of the wood stick or nail to the back of the movable near the center, using masking tape.
- Attach cords with masking tape to the back of the movable parts.
- Your hands are now free to make parts move, run, swing, tilt or dance.

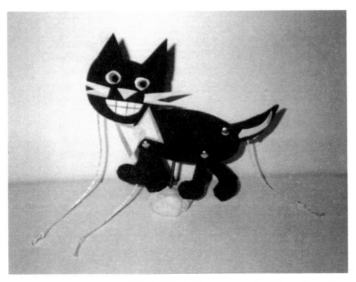

MT-5: Black Cat mounted with nail on clay; strings attached for movement

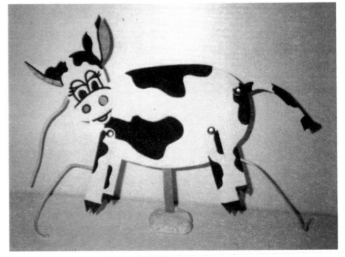

MT-6 White Cow mounted with stick on clay; strings attached for movement

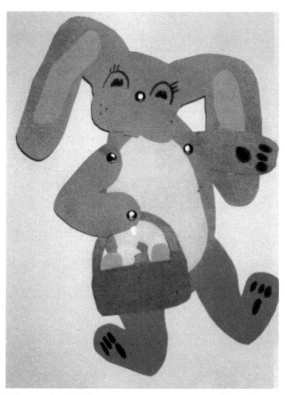

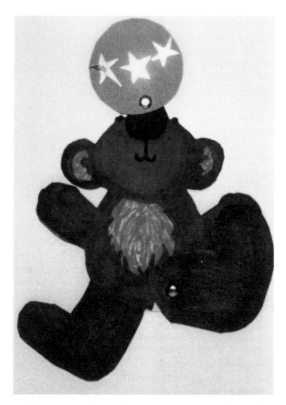

MT-1: Rabbit with a Basket, construction paper and markers

MT-3: Bear Balancing a Ball, construction paper and markers

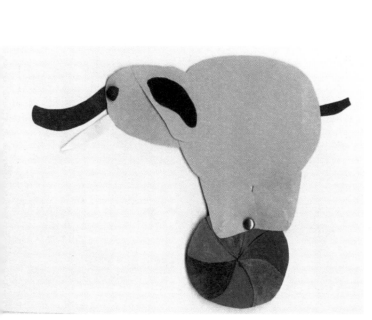

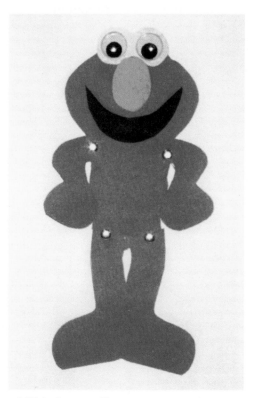

MT-2: Elephant Rolling a Ball, construction paper and markers

MT-4: Cartoon Character, construction paper and bubble eyes

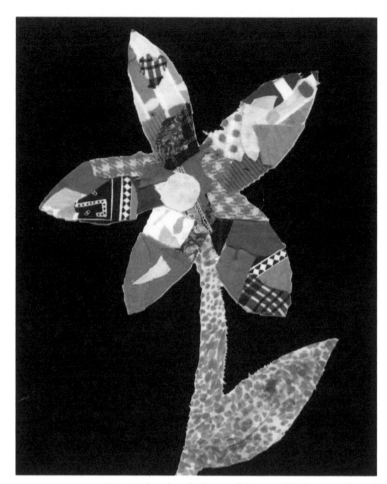

F-1: Multicolored Flower, fabric on black poster board

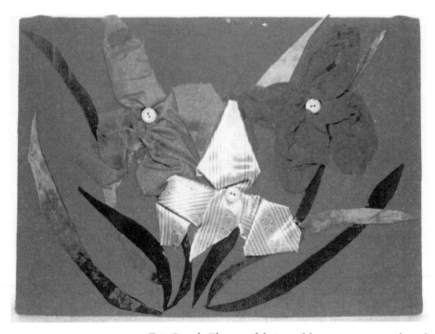

F-2: Purple Flowers, fabric and buttons on poster board

3 FABRIC and WALLPAPER COLLAGE

FABRIC HOUSE AND GARDENS

Description

Combining texture and pattern in any medium is an exciting artistic process and fabric provides an unbeatable opportunity to do this. Fabric already contains many of the artistic elements of color, shape, texture, pattern, design, rhythm, balance and spatial relationships. Try to give attention to design considerations that include those elements as you compose your project. A large number of illustrations are provided to display a range of possibilities to help you in that effort.

Suggested Materials

- Choose backing: cardboard, thin wood or foam core
- Fabric scraps, buttons, yarn, felt, lace, etc.
- White glue
- Good sturdy scissors
- Wood stick
- If needed for hanging: screw eyes and picture wire or self stick picture hooks

Process

1. Assemble your materials, collecting a variety of fabric colors and patterns.

2. Select a flat firm surface for backing.

3. Select background fabrics according to the picture concept. For example:

 - If your picture is a landscape, you might choose something in the green or brown family and sky blue.
 - A seascape might be blue-green.
 - A cityscape background might be gray or white to set off the buildings.
 - A home interior or exterior could match your own dwelling.
 - An abstract composition will be anything that works for you.

4. Use undiluted white glue to adhere the background fabric to the surface.

5. Cut scraps of fabric into shapes to form the components of the picture.

6. If you are not working alone, you might start a group wall hanging by combining individually made fabric pictures. Having a unifying theme is a good idea, but the artistic process of fabric selection and pictorial ideas should be left to each artist.

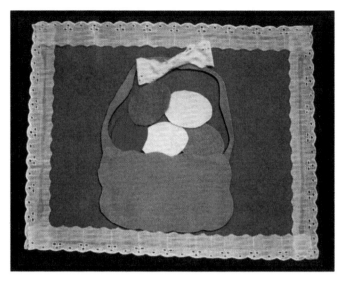

F-3: Basket of Colored Eggs, felt bordered with lace

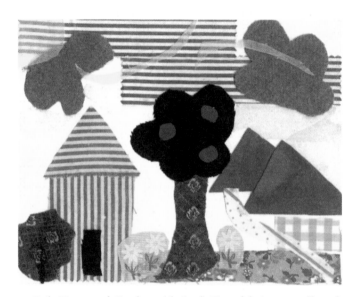

F-4: House and Garden with Apple Tree, fabric on cardboard

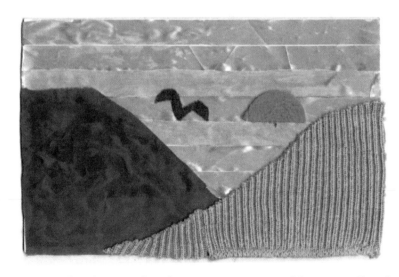

F-5: Sunset and Bird over Mountain Range, fabric on cardboard

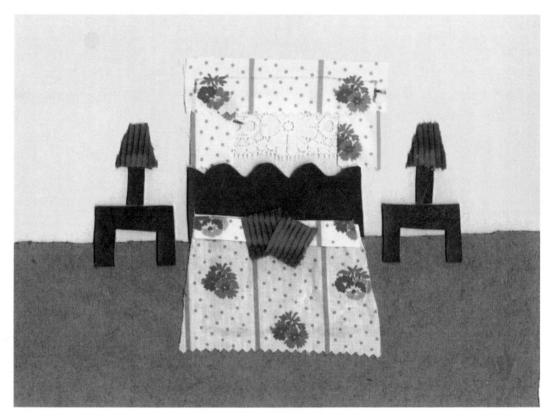

F-6: Bedroom, fabric on cardboard

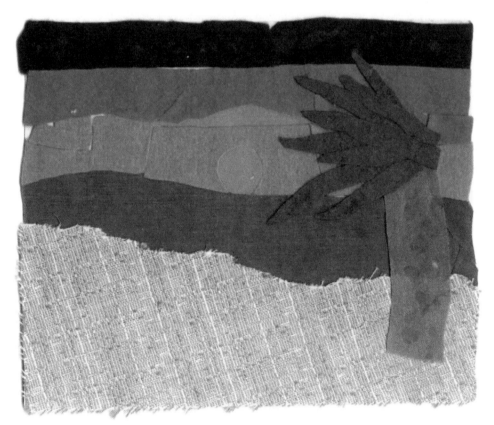

F-7: Sand Beach and Windy Sunset, fabric on cardboard

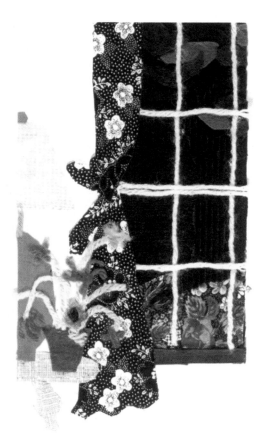

F-8: Window, fabric and wool on cardboard

F-9: Abstraction, fabric on poster board

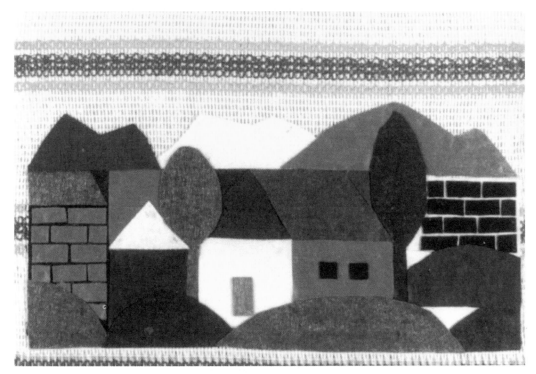

F-10: Farmhouse, fabric on a washcloth

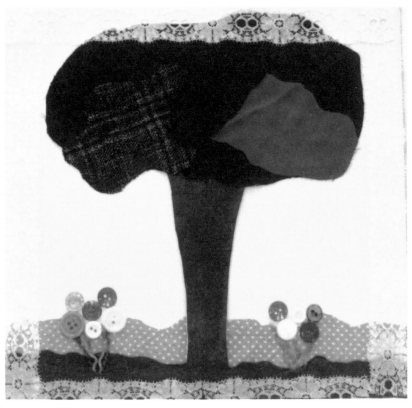

F-11: Tree with Button Flowers, fabric and lace

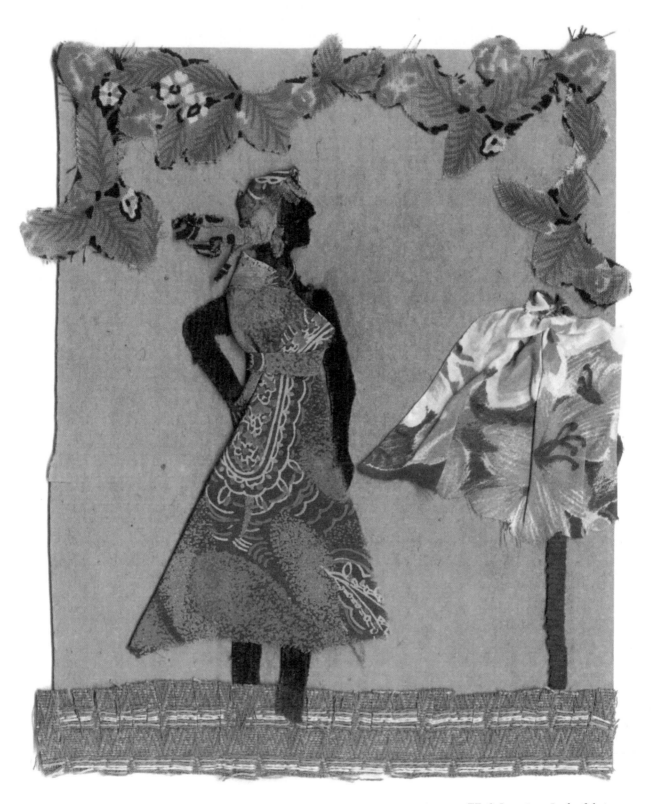

FF-6: Jamaican Lady, fabric

FOLKS IN FABRIC

Description

Folks in Fabric projects can be hung as decorative wall designs similar to the scenes in Fabric House and Gardens. Or a cardboard doll can be created and clothed with fabric outfits. Clothing can be changed to fit the occasion. Pasting an end of the outfit with a thin seam of glue stick makes clothing easily removable. If the doll is to be played with "big time," Velcro binding might be considered. If not, simply paste the doll on cardboard to be dressed, or stand her up on a cardboard stand.

Creating Folks in Fabric makes for a productive group project:

- A display of folks in uniforms to show community services offered in the town.
- A project for "seniors" preparing dolls for "juniors."
- Teen fashion contests designing clothes.
- A supplement to school class lessons:
 - Representing figures in mythology
 - Dressing characters in a story or book
 - Representing folks from other countries
 - Holiday costumes.

Consider drawing in colored pencils or markers to provide a surrounding for the character. Words, too, might be added, perhaps a foreign word or two as well.

Suggested Materials

- All of the materials listed in Fabric House and Gardens on page 23
- A base of stiff cardboard or wood to support the figure, extending front and back to keep the figure from toppling
- Wool for hair
- Buttons for clothes (and perhaps eyes)
- Colored markers; pencils

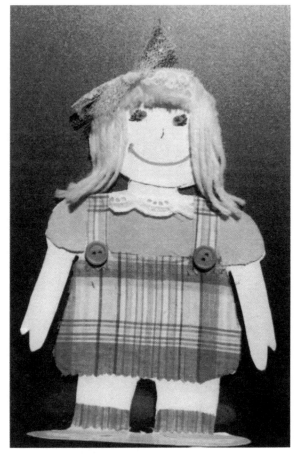

FF-3: Happy Paper Doll, fabric, paper, cardboard, buttons, wool and markers

Process

1. Plan whether your figure will be a decorative wall hanging or a standing doll.

2. Decide the concept:

 - a paper doll with a change of clothes wardrobe
 - a single figure representing a character
 - a figure to be followed by others representing a group, such as people who work the farm or performers in a circus, or hip teens or monsters.

3. Follow the basic procedures for Fabric House and Gardens, but with the simplicity of a single figure on cardboard.

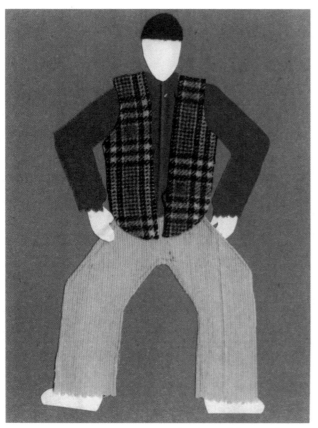

FF-1: Man in Plaid Vest, fabric and paper

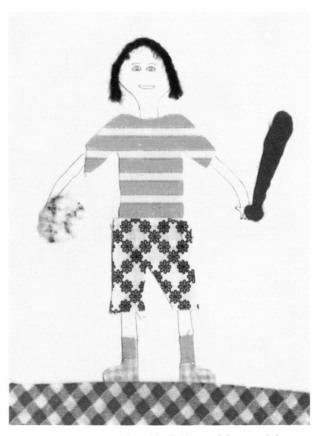

FF-4: Softball Player, fabric and drawing

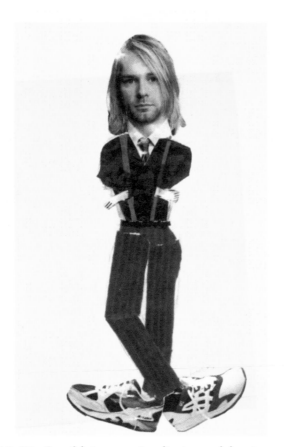

FF-2: Hip Guy, fabric, magazine clippings and drawing

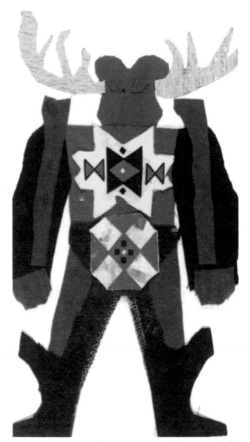

FF-5: Monster, fabric and felt

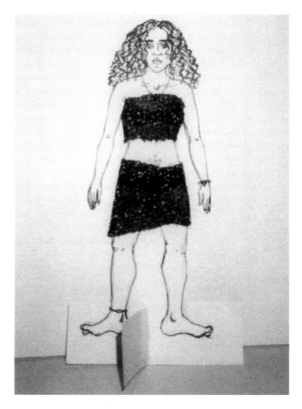

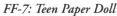

FF-7: Teen Paper Doll

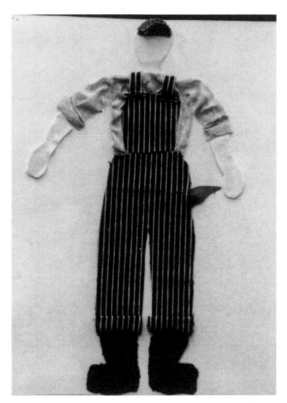

FF-8: Trainman, fabric

4. Draw the figure in pencil.

5. Glue fabric where you want it.

6. Add a pencil drawing or colored pencils or markers to the figure and/or its surroundings, as you wish.

7. If the figure is to be free standing, glue a firm strip of cardboard to the back of the figure with a horizontal fold at each end, one end to attach to the figure, the other to the base. For minimal manipulation of the doll, simply bend the bottom of the cardboard back or make a notched cardboard stand by crossing two pieces of cardboard.

8. If the figure is intended as a wall hanging, add surroundings by drawing them on the cardboard or gluing on additional fabric.

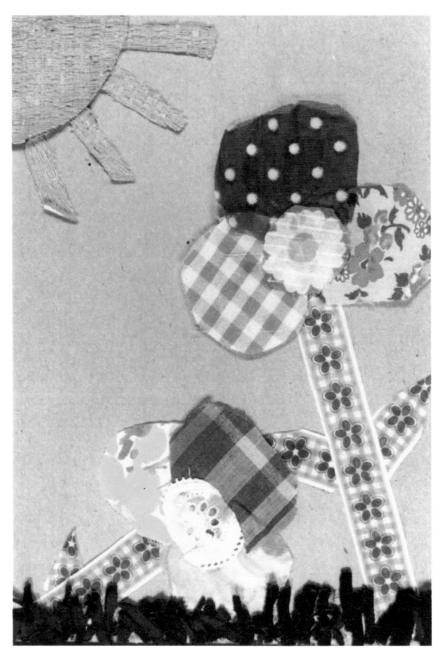

FW-1: Two Flowers in Sunlight, wallpaper and fabric

FABRIC AND WALLPAPER COMBINATIONS

Description

Whether you use wallpaper alone or with fabric, with added drawing or paint, the combinations offer a number of artistic advantages.

- Wallpaper is flat with only the simulation of texture, while fabric has genuine texture. This makes for an interesting marriage.
- Wallpaper has repetitive patterns and this provides an assist to you as you strive for balance and rhythm in the picture.
- Because wallpaper is flat, you can easily overlay one pattern on another; then you can highlight with fabric. This gives you a lot to work with whether you are working abstractly or creating a scene.
- Some wallpapers are highly textured, which provides an interesting surface for acrylic paint.

Suggested Materials

- All materials listed in Fabric House and Gardens on page 23
- Books of wallpaper samples

Process

1. The method is essentially the same as for Fabric Wall Hangings.

2. Choose a piece of wallpaper for the background; it does not have to back the whole picture. Alternatively, you might choose fabric for background.

3. Use the flexibility of easy cutting to explore small sections of the wallpaper for use; combine these with other small sections of wallpaper in your designs.

4. Try combining wallpaper with mixed media, such as paper strips or drawings in pencil, colored pencils or markers.

5. Don't be afraid to be "way out" in exploring this project. The colors and textures seem to beg for imaginative extravagance.

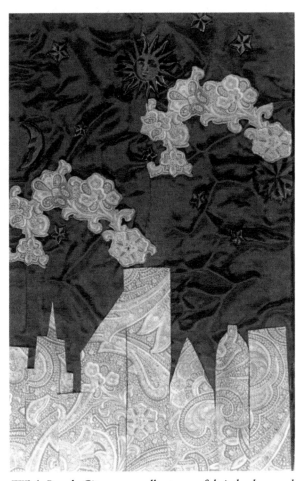

FW-4: Purple Cityscape, wallpaper on fabric background

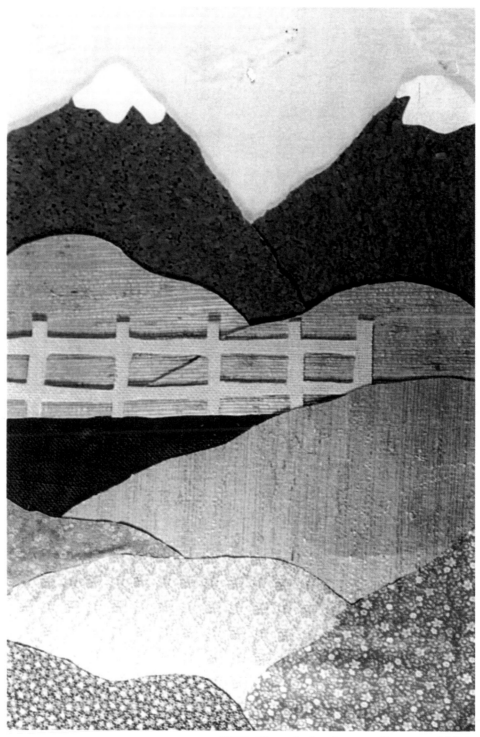

FW-2: Mountain Landscape, wallpaper and fabric

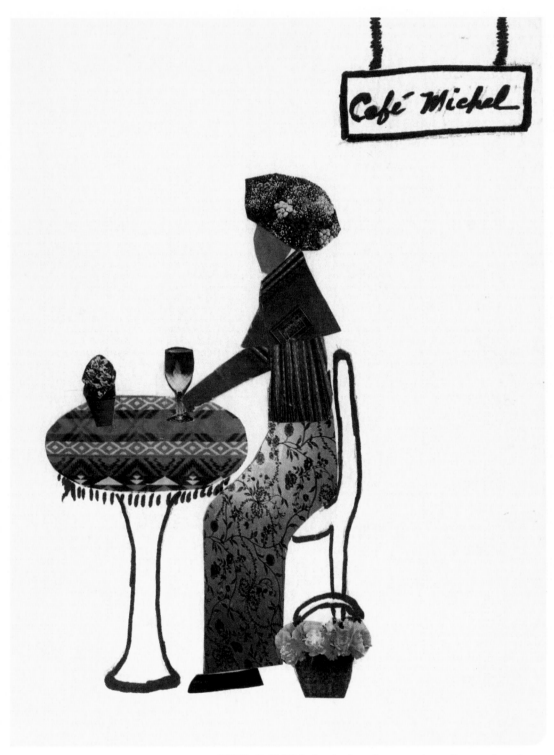

FW-5: Café Michel, mixed media magazine collage and markers.

MIXED MEDIA

Description

How about putting together a *combination* of some projects described so far? Using wallpaper and magazine collage you can create an artistic picture with a story component. When you add drawing in either marker or pencil, perhaps with some words thrown in, you set a scene.

Materials

- Wallpaper samples
- Colored construction paper
- Scissors
- Colored markers or pencils
- Oak tag
- Glue sticks
- Magazines
- Fabric scraps

Process

Get your ideas from magazines if you don't have something already in mind. Magazines that focus on house, garden, sport, nature, people, vehicles, travel ... all are rich in color illustrations and that's the main source for your inspiration. The example titled, "Café Michel" (FW-5) is mainly comprised of patterns cut from magazines, very few whole images, yet a picture is made and a kind of story evolves.

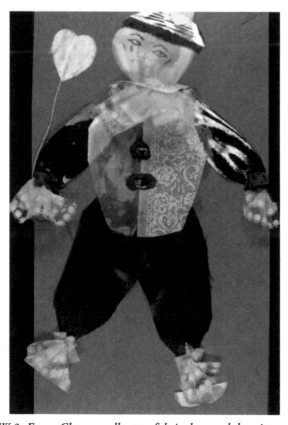

FW-3: Fancy Clown, wallpaper, fabric, lace and drawing

Wallpaper and strip-paper collage make a fine marriage. When you build up layers of these two-dimensional media you create an effect of low relief. In "Flower Garden," the background is wallpaper. Superimposed on that are cut-outs from wallpaper sheets: on the first layer, white shapes in the form of clouds; in the next layer, cut out shapes of flowers and leaves. In front of that are glued paper strips in the form of triangular sprouts of grass. The effect offers the viewer a sense of shallow perspective.

Of course, there are other media and materials you can mix to create intriguing collages. Included here are only those described up until now in the text.

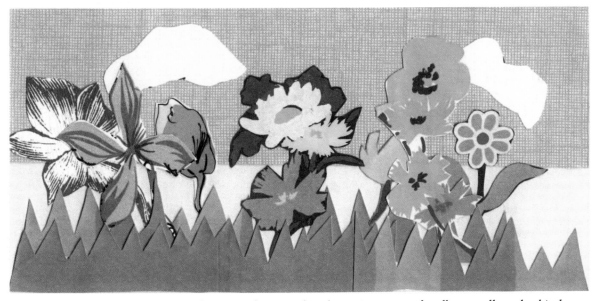

FW-6: Flower Garden, mixed media: strip-paper and wallpaper collage glued in layers.

4 DECORATIVE PROJECTS

- **Personalized Notepaper**
- **Painting on Plexiglass, Glass and Tiles**
- **Painting on Wood**
- **Painting on Anything**
- **Plaster Trivets and Wall Hangings**
- **Plexiglass Sculpture**

Description

Changing the surfaces in painting to obtain a special result is both challenging and fun. It can also be utilitarian, as in creating notepaper or trivets. Whether or not your plans have material usefulness, however, always try to make that use secondary to the artistic process. That is, mix colors to create subtle hues and tones, rather than using paint directly from the tube or jar; explore form and spatial design, being especially alert to the "Aesthetic Elements" listed in the Introduction.

Although the surfaces in most cases will be cast-offs, you need to bring art supplies such as brushes, a tray of watercolors and a box of acrylic paint jars or tubes to these projects. Finding the cast-offs might send you scavenging to:

- Lumber yards where you can pick up small sections of wood cut from large boards.
- Glass shops where leftover plexiglass from window pane jobs may be yours for the asking.
- Dollar Stores where numerous items reside to inspire artistic work. Acrylic paint should adhere to the surfaces of most of the following items:
 - Solid color vases
 - Masks
 - Reverse side of plastic signs
 - Party trays
 - Black or white place mats
 - Solid color tissue box holders
 - Plastic file folders
 - Plastic and ceramic bowls and flower pots.
- Around your house or someone else's might be leftover bathroom tiles and glass frames bought for pictures you never got around to inserting. All of these materials, if not cast-offs, are inexpensively purchased.

PERSONALIZED NOTEPAPER

Description

With color photocopy readily obtainable, original drawings and paintings can be effectively reproduced. In addition to creating personalized notepaper you might want to design a logo to use when you communicate with friends and family. Original holiday and greeting cards follow similar processes.

Various Processes

1. Make a simple line drawing. Draw lightly with pencil, then go over the lines with ink and when dry, erase the pencil lines with a gum eraser.

2. Use watercolors as a wash to give some color to the drawing.

3. Or paint the design with acrylics for a stronger hue and to add volume to your drawing.

4. Or embellish your line drawing with colored pencils or markers.

5. Or peruse images and words in magazines to spark thoughts about your relationship with the potential recipients and what you want to convey. Then cut out come of these images and words to create a collage.

6. Make as many photocopies of the picture that will fit on a page; then photocopy the page to make more.

7. The computer offers some tantalizing avenues for "procreation" of images, from creating and coloring line drawings to manipulating readymade graphics.

PAINTING ON PLEXIGLASS

Description

Plexiglass is lightweight, smooth, and depending on thickness, reasonably sturdy. Painting on glass or plexiglass produces translucent effects. Your painting, placed in the window, will catch the sunlight and become luminescent. Or you might put it in a frame for hanging. You can buy sheets of plexiglass in a hardware store along with a cutter and special glue.

The containers and lids you toss out holding salads, fruits and deli items are paintable with acrylics as well. Several painted lids of equal size can be glued to a wall for an interesting decoration and painted containers can serve as …well, containers.

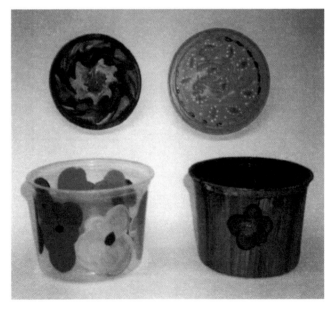

DP-1: Decorated deli containers and lids

Process

1. Using whole sheets: Score a sheet of plexiglass with the cutter, then bend it sharply on a straight edge, such as the side of your work table.

2. If the painting is to be placed in front of a window, drill a hole in the Plexiglass before painting in order to hang it. Dilute paint for translucency.

3. Use acrylic paints or watercolor. Remember that acrylics are soluble in water until they dry; therefore, you should paint directly on the surface, erasing unwanted marks merely by rubbing with a damp rag.

4. Measure the picture and find a simple wood picture frame from Wal-Mart; it comes conveniently equipped with glass cover and hanging wire.

5. Painting plastic containers and lids: Use a hole punch or awl to make a hole at the top of the lid for hanging; this can be done before or after painting. You might hang several lids together and allow them to dangle.

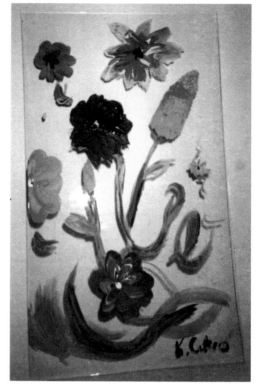

DP-2: Floral painting on glass

PAINTING ON GLASS

Description

First, be careful of sharp edges. You are better off finding a nice piece of glass to paint on than cutting one. Although cutting is a straightforward process, it takes some experience, and the finished project will be fragile unless encased in a frame. Use acrylic paints, remembering to mix the paints to obtain subtle hues. Erase unwanted or unintentional strokes by removing with a damp cloth before the paint dries.

Process

1. Follow the processes suggested for Painting on Plexiglass, with the exception of scoring, cutting and punching a hole.

2. The easiest way to proceed is to buy an inexpensive glass frame, remove the glass, paint directly on it and then replace the painting in the frame.

PAINTING ON TILES

Description

Tiles are often left over from bathroom and kitchen redecorating. Tile stores sell leftovers and odd lots too. Tiles make nice trivets if surfaces have slight texture and are not too slippery. You can put hot

coffee cups on them or bars of soap or plants. Tiles of all kinds make good wall decoration; they can hide cracks in the wall too.

Process

1. Painting on tiles is best done with acrylics, which will also add texture. Paint directly on the tiles just as you do in the plexiglass and glass project.

2. If you want the colored border of the tile to show, tape masking tape evenly around all four edges before you begin painting; remove the tape when the painting is dry.

3. Use tile cement to secure the tile to a wall, if that is intended.

4. Consider making a series of tiles with a unifying theme for a wall, an unusual way to decorate a normally unattractive area like a garage or basement. Of course, the kitchen and bathroom are welcoming areas for a series of decorated tiles. Uncoordinated tiles in color and theme usually work well too, somewhat like a patchwork quilt. The square shape of the tiles seems to unify a display of disparate colors and images.

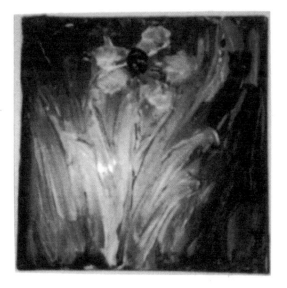 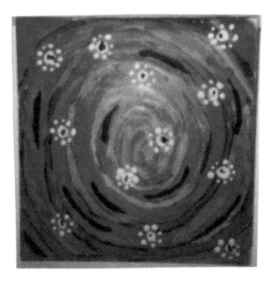

DP-3: Two acrylic paintings on tiles

PAINTING ON WOOD

Description

Painting on wood gives you the opportunity to make a number of original utilitarian items and furnishings. From small to large, unpainted wooden items have beautiful surfaces for decorating. A door or plank of wood cut to size can be put into service as a table top; unfinished or old furniture such as a rocking chair, child's dresser or baby cradle can be decorated.

It's a good idea to start small, perhaps with book ends. Old wooden toys, bowls, stacking tables, benches, frames and similarly sized items can provide good practice for you and allow you to explore the process.

Various Processes

1. Look long and hard at the piece you plan to decorate to get ideas. Think about where the piece will be placed and get ideas about color from its potential surroundings.

2. Prepare the wood if necessary by sanding. Progress from course grades to finer grades to get scratches out, then vacuum to get rid of dust.

3. Unfinished furniture bought at a store is generally ready for painting and may not need sealing. Similarly, new wood may not need sealing, as acrylic paint will do the job as it is applied; however, if the wood is very porous, it could take a lot of acrylic paint and so you might want to prepare it before beginning:

 • Apply a coat of water based polyurethane which will seal the wood without interfering with the paint you plan to apply. Sand lightly before painting.
 • Or brush the wood with a mix of equal parts of shellac and denatured alcohol; this will seal the wood and add a soft sheen.

4. Mix your acrylic paint colors on a disposable palette or plastic mixing tray to obtain subtle hues and tones.

5. Practice on a scrap of similar wood to see how the grain and color of the wood influences your colors and design.

6. If you intend to make less of a spontaneous design, you might draw your picture on paper first. If you make a drawing too elaborate to copy, turn the paper over and firmly rub charcoal or soft pencil over the back. The drawing will come through onto the wood. Go over the lines to see them more clearly. Think again about how and where color can enhance the design.

7. Try not to be frightened of the surface, as if it is too important to risk "ruining." Treat it as ordinary paper. The worst that can happen is you paint over and start again.

8. If you want the grain of the wood to show through, paint with slightly watered down acrylics. Otherwise, keep the paint opaque. If the wood surface is lovely, let it show around the painting.

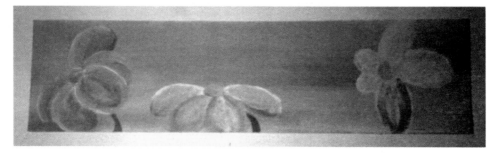

DP-4: Blue and White Flowers, diluted acrylic paint on wood panel

PAINTING ON ANYTHING

Indeed, acrylics are so versatile, you can pretty much paint on anything that is clean, reasonably flat and sturdy and has a surface or background that appeals to you or can be painted over. True, acrylic

paint may not stick to some surfaces, but it will on many. In addition to the usual suspects such as canvas board, canvas, and watercolor paper, try painting on leftover wallpaper, steel, vases, plant containers, flower boxes, tennis shoes, belts, shirts and whatever works.

To paint on material, stretch the fabric flat (there are hoops in crafts stores for this). Iron the finished piece covered with a cloth. This deters colors from running in the wash. Wash the garment by itself, when the time comes, to make sure it doesn't run (no guarantees). And don't paint on ware from which you intend to drink or eat.

PLASTER TRIVETS and WALL HANGINGS

Description

This project is as artistic as a watercolor or acrylic painting on paper; the difference is that the finished product has useful applications. A plastic lunch or dinner plate serves as the foundation. When filled with plaster, the plate is removed, the plaster is painted, and the finished product can serve as a trivet, paper-weight, or with the insertion of wire during the pouring process, a wall hanging. White plaster, colorfully and aesthetically painted and then sprayed with plastic coating can be an artistic production whether for use or display.

Suggested Materials

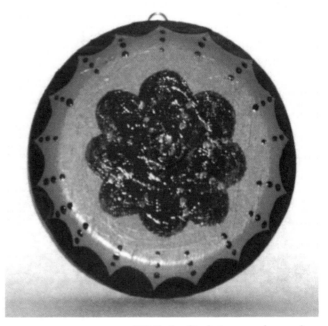

- Plastic-coated plates, lunch or dinner size according to size preference
- Aluminum wire, thin but strong and bendable (about 18 gauge)
- 25 lb. bag of plaster of Paris (from hardware store)
- Mixing bowl (approximately 3-quart size, but will depend on quantity of plates to be poured)
- 9" paper cup
- Watercolor paints or acrylic paints and brushes
- Source of water
- Optional: clear water based polyurethane spray

DP-5: Acrylic design on plaster plate.

Process

1. Preparation: You should plan on filling several plates at once, so that you will have them on hand to paint when the spirit moves you.

- Lay out the plates on a flat surface easily cleaned.
- Cut 4-inch lengths of wire and bend into U-shaped loops. This will be used for hanging the finished plate.
- Find the size bowl needed for the amount of plaster to be mixed; this will depend on how many plates you want to produce. A 3-quart size bowl half filled with water to which plaster of Paris is added will produce about 10-12 lunch plates.

- Have a 25-lb bag of plaster of Paris on hand, though you will not need all of it.
- Fill your bowl half full of cold water.
- Work with a helper if you can because there is much to do in little time.

2. Mixing the plaster:

- Pick up a handful of plaster and distribute it into the pail or bowl;
- keep your hand close to the surface as you spread the powder around, but do not touch the water.
- Avoid dumping in the plaster and avoid shaking the bowl, which will create air bubbles. Work quickly but steadily. The process will take about 4 minutes

3. Stirring the plaster:

- When the plaster rests in mounds without sinking it is ready to be stirred. Stir by hand, keeping your hand under the water while squeezing out any lumps.
- Stir quickly but smoothly, as the setting time is approximately 5 minutes and you need time to pour the plates.

4. Pouring the plaster:

- Working quickly, dip a 9-inch paper cup into the plaster and use this to pour the stirred mix into the waiting paper plates.
- Jiggle the plates lightly to spread the mix across the entire surface of the plate. Make sure the table top remains flat.
- Before the mix sets insert a U-shaped wire into the plate, 2/3rds in the plaster and 1/3rd exposed.
- Do not move the plates while plaster is setting.
- If the mix begins to set before all the plates have been poured, pour the remaining plaster into a paper cup to use later as a form which you might want to carve with a paring knife.
- Wait several hours until the plates have fully set; then stack them carefully, still in their plastic plates, to use later.

5. Painting the plaster plate. Choose to paint the plate with watercolors or acrylics.

- Before painting, if you wish, decoratively incise the plaster with a pointed tool. This might create interesting shadows on the painting, or if incised deeply, might give a quality of low sculptural relief to the project.
- With watercolors, a pleasing "fresco" appearance is created as the plaster absorbs the paint, offering a soft, somewhat transparent effect.
- Spray the dry, finished watercolor with clear polyurethane for protection.
- With acrylics, the plate takes on a brighter look, an opaque appearance in which the plaster is completely covered. The finished acrylic painting need not be sprayed afterwards, as acrylics themselves form a shield against dust.
- Whether using watercolor or acrylic, paint as you normally would on paper. Be free and be bold. Mistakes or mind changes can be lightly scraped off if not painted over.
- Avoid using the plaster plate to write names or insignias or cliché symbols such as hearts and mushrooms. Create a composition. Be inventive. Take a chance!

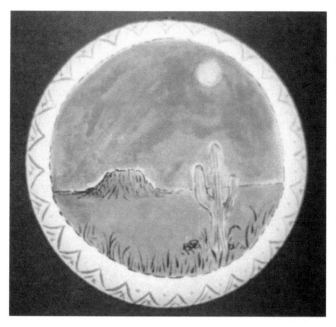

DP-6: Desert Scene, watercolor on plaster plate

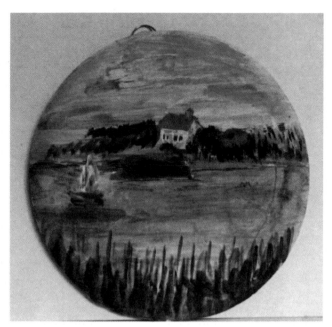

DP-8: Elaborate watercolor landscape on plaster plate

PLEXIGLASS SCULPTURE

Description

Plastic rods, tubes and sheets can be bought in many colors and found in hardware as well as crafts stores (look for "plastic" in the Yellow Pages). These can be melted and assembled in various creative ways and glued. Dollar Stores also carry plastic items that you might manipulate into sculptural shapes by the processes described.

Process

1. Find a suitable piece of plastic or cut a piece of plexiglass to the size you want (see Painting on Plexiglass page 39.

2. Place the piece on a sheet of aluminum foil and put it into the oven at low heat (about 200 degrees Fahrenheit).

3. The plexiglass will begin to melt in a few minutes. (You may already have discovered how easily plexiglass can warp just in your dishwasher.)

4. Using oven gloves, remove the piece and quickly bend or twist it into an unusual shape. You work quickly because plastic only bends while warm.

5. To expand the project, melt and shape several pieces. Melt only one piece at a time to allow each to be shaped while still warm.

6. Adhere the shapes to one another using very small dollops of crazy glue. (Follow directions on the package.)

7. Paint the plastic sculptures with acrylics if you wish.

5 PAPER ROLL PUPPETS

CREATING THE PUPPETS

Description

The puppet project is imaginative in both its craft and in the "personality" development of the puppet. The puppets, as you form them, will be invested with distinctive personalities. Their features may be suggested by a mix of your own personality and imagination as creator; your friends, enemies, and family members; or merely your whims of the moment. It is helpful to take a look at the puppets illustrated before beginning the project to see the array of characters that can issue forth from the lowly toilet paper roll.

If circumstances permit, you should try to create an improvisational play around the puppets. A dramatic presentation adds another dimension to the project and is an excellent undertaking for group situations. It would be a daunting challenge for you as a lone puppeteer but still possible. See the section, Creating a Play, to learn how.

Forming the Heads

In creating the identity of the emerging "person," you will be making many decisions with regard to features, hair and clothing. These identities may remind you of a friend, spouse, parent, sibling or child, and perhaps specific events connected with these individuals. You may not know quite where you are going when you start, but rather amazingly, a personality evolves.

Suggested Materials

- Discarded toilet paper rolls
- White glue with applicator stick
- Cotton or fiber fill
- Fabric scraps
- Old nylon stockings
- Knitting wool in selected colors
- Buttons, lace, ribbons, etc.
- Needle and assorted thread, particularly colorless, white and black
- Cub stapler with staples

Process

- Coat a bare discarded toilet paper roll all around with white glue, leaving one inch at the

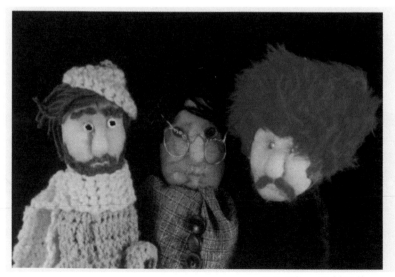

P-2: Three Odd Fellows

bottom uncovered.

- Place cotton (or fiber fill) around the roll. How much cotton to use will determine the size of the head. A child has a larger head than an adult.
- The one inch of bare roll exposed at the bottom is where clothes will attach.

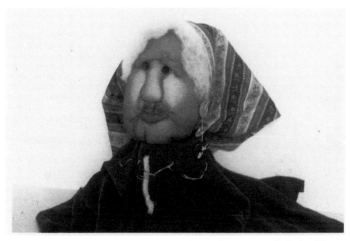

P-1: Woman with Babushka

2. Cut a length of discarded nylon stocking and pull it over the cotton. The color tone of the stocking will determine the skin color of your puppet.

3. Tie the nylon stocking on top of the roll (unless it is the toe part of the stocking which is already closed).

4. Stretch the stocking down, leaving about 3 or 4 inches of stocking beyond the roll. Cut off the remaining length.

5. Staple the bottom of the stocking to the inside of the paper roll with the flat side of the staples facing the interior (so you don't scratch your hand when you hold it).

Creating a Character

Now that you have the basic head, you can begin shaping the features and adding the materials that will make the head become somebody.

1. Pull and pinch the cotton forward against the nylon in various places to develop the prominent facial features, for example, the brows, cheeks, nose, lips, and chin.

2. Sew a few stitches in various places to keep these protrusions in place and to add expression to the face. Pay particular attention to the nostrils, lips, cheeks and brows.

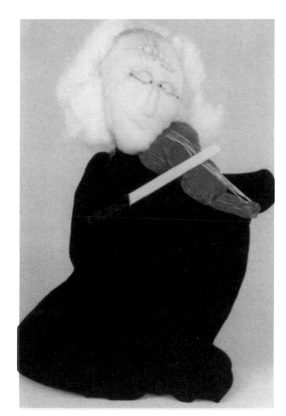

3. Create hair from a ball of wool. Color as well as style may determine the age of your character. Embellishments could include braids, bangs, bob, flip, Afro, whiskers, beards, brows, and so on. Adornments might be ribbons, feathers, curlers — you name it — added with assorted fabrics and found objects.

P-3: Violinist

47

4. Hats, bandanas, babushkas, caps — head coverings of many types — add both charm and distinctive identity to the character.

5. Facial features are created with buttons, wool, ribbon or fabric; these can be sewn directly onto the nylon. If sewing is difficult, you can fasten some of these things with white glue, although this will be less permanent. Some features can be drawn on with markers.

6. Accoutrements such as eyeglasses, cigarettes, pipes, jewelry and so on, can be added with wire and assorted trimmings. Tools of your character's trade can be added with lace, leather, wire or any other trimming materials that you think describes your "person."

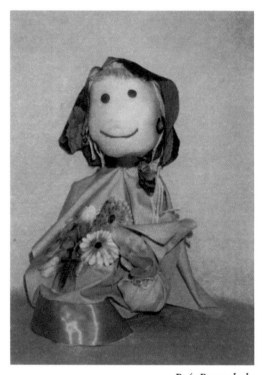

P-4: Pretty lady

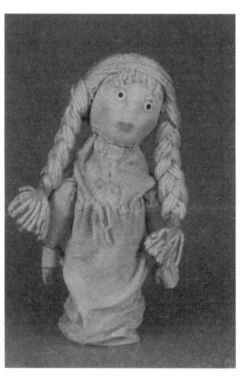

P-5: Little Girl with Braids

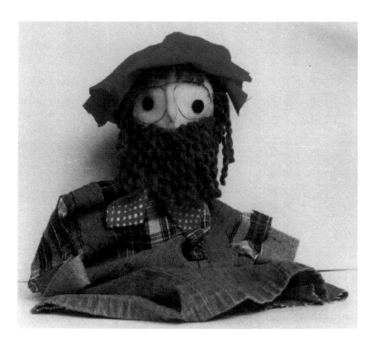

P-6: Philosopher

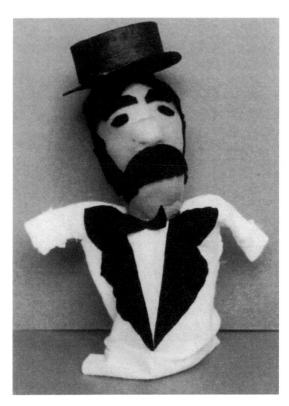

P-7: Man in Tux

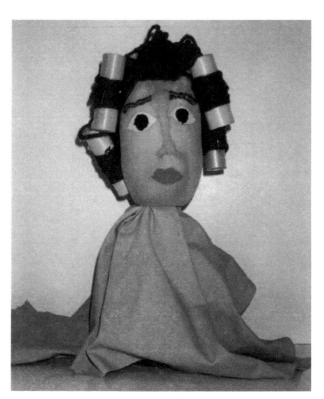

P-8: Girl with Curlers

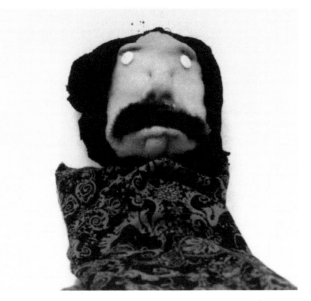

P-9: The Boss

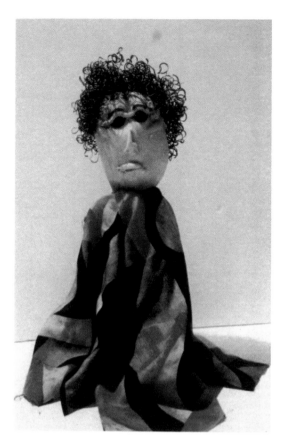

P-11: Woman with Curly Hair

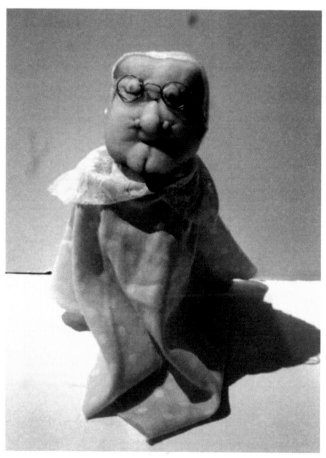

P-10: Grandma

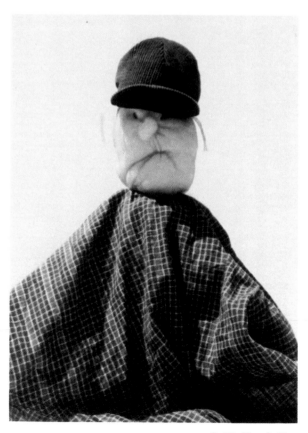

P-12: Tough Guy

Adding Clothes and Artifacts

1. Double over a piece of material, a little wider than the puppet's head and long enough to cover your hand and a portion of your arm. This will be used as the body of the puppet as well as its clothes.

2. Cut a thin slit in the middle of the fold a tad narrower than the bottom of the toilet paper roll; then, holding the roll upside down, pull the material tightly onto it. Staple or sew the material into place on the bottom of the paper roll.

3. Sew the sides of the material, leaving space for your fingers to emerge on each side as the puppet's arms. If you don't want to sew, leave the sides open. Poke your thumb and fourth finger against the front of the material and cut small holes in those spots for thumb and finger to come through the material as the puppet's arms

4. You can decorate the puppet's clothing if you like, adding veils, scarves, costuming and apparel to fit the character's personality, station in life, nationality or the particular situation or occasion he or she is involved in — say a wedding or rock concert or jungle safari.

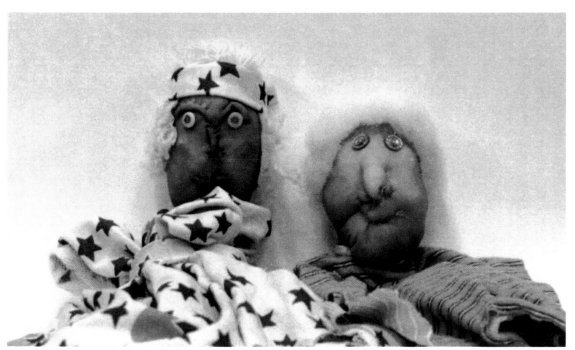

P-13: Two Personalities

P-14, P-15 and P-16: Three rolling scenes for a puppet play

CREATING A PLAY

Take any three of the characters illustrated in this chapter and you could probably imagine a play. A good play is devised first around the characters, and after that, the plot. So take a good look at who that character of yours is — and the invention of others working with you — and dream up what kind of trouble they could get into. You could work alone and create several puppet characters for a play, but ideally, you will not be alone and other characters will have been created along with yours.

Assuming that you are working in a group, here is a way to structure your play:

1. Ask questions of perhaps four or five characters, such as:

 * How old are you? Where do you live?
 * Do you work? What do you do? Do you go to school? Are you a bum?
 * Are you married? Do you have kids? Grandkids? Are you yourself a kid?
 * Where do you like to hang out? What do you do for fun?
 * Where are you from?
 * Are you a nice guy, a mean guy, a clever guy, a sweet guy, a tough guy...?
 * What do you plan to do with your life?

2. Think of an idea for a plot which centers around the identity and personalities of the characters.

3. Develop a series of actions introducing the characters and establishing the plot.

4. Imagine a conflict of some kind between or among the characters, or a problem due to an outside force or event.

5. Intensify the conflict to a crisis level.

6. Solve the crisis.

7. Create an eventual resolution.

Don't write the play, just take some notes. With a few people sharing ideas, the plot will emerge almost spontaneously. When it comes to producing the play, the characters, knowing who they are, will ad lib their parts. It will be impossible, anyway, to read "script" behind the "puppet stage" and you will have your hands full just manipulating the puppets. Add scenery, have a few impromptu rehearsals to get the feel of the play, practice voice projection and puppet movement on stage, and in no time you will have a hit on your hands.

Making Scenery

To make the puppet play into a fine presentation for others, you can prepare scenery which will roll from one scene to another behind the players, in effect as a backdrop.

* Using mural paper (ordinary bond paper supplied on a roll), draw two or three scenes, or more if the plot requires, each as wide as the portion of the table you are using as a stage.
* Color the drawings with markers.
* Tape the side ends of the paper onto two long broom handles, one on either end, and roll it up.

- Set up two makeshift screens or curtains on either side of the "stage," behind which two volunteers will stand to unroll the scenes as they appear in the play.
- Alternatively, make each individual scene, the width of the "stage," and simply hang it on a wall behind the players. The volunteers will have to show themselves to the audience during scene changes. The scenes should be tacked one on top of the other to simplify changes.

Lyrics, Melodies and Sound Effects

Music is fun to add to the improvisational play, either live or recorded. You can even create your own. Write a song to express some action or feeling. To do this:

1. Think of what you wish to say and make a two-line poem that expresses this.

2. Add another two lines.

3. Consider the feeling you want to evoke: is it happy, sad, melancholy, angry, frightened, menacing? Then establish a lyrical, moody, thundering, romantic, scary or mysterious tone for those feelings; pace the tempo accordingly.

4. Consider what method of accompaniment would work with the words, the tone and the pace: a drum beat, voice humming, piano music, whistles, recorded music, rap?

5. Sound effects add realism and texture to the play. Horse's hooves: fingernails playing on the table; wind howling: blowing through your lips off stage; bells ringing; knocking on doors; and so on.

Improvising a Stage

Any table long enough for people working the puppets to fit behind can serve as a suitable puppet stage. Obviously, more puppeteers requires a longer table. The height must be high enough for puppeteers to either stand, kneel or sit behind, a choice which gives you some flexibility.

- Drape the table with sufficient material to cover the surface and to hang all the way down the front and sides of the table, hiding the puppeteers.
- Tape down the edge of the drape with masking tape so that it won't slide off.
- Place a bench behind the stage for the puppeteers to sit on; alternatively, they might kneel or stand, just so long as they are not seen and their hands reach the surface of the table (stage).
- Set up chairs for the audience directly in front of the stage; alternatively, the audience can sit on the floor.

Projection and Performance

Puppet voices have to project clearly and loudly to be heard from beneath the table.

- Each puppet must have a *distinctive voice* so that the audience is able to discern which puppet

is talking. The audience gets no information other than the puppet's distinctive voice and actions to enable it to follow the action.

• *Exaggerated* puppet movements are necessary "on stage." Every time the puppet speaks from behind the table the puppet on stage must *move* — up and down or sideways, any way — to demonstrate that this is the puppet who is talking. Puppets can scoot across the length of the table while they are talking. The wilder the moves, the more exciting the play: the old "Punch and Judy" plays had a lot of slap-stick action.

• Hands holding the puppets must try to maintain as *vertical a stance* as possible so the puppet's head can be seen. The tendency of the wrist is to bend down, thereby obscuring the puppet's face from view.

• If you invite young people to see your show, you might ask them for an imaginary 50 cents, then collect that. It makes "show time" more real and children will like the fun of that.

• The Host or Announcer of the play should welcome the audience, ask some questions, such as "Have you ever seen a puppet show?" "Was it scary?" "Was it funny?" "Was it silly?" Puppet shows historically involve the audience, so encourage your audience to cheer or boo or hiss at some of the characters and laugh out loud at others.

• After the play, the puppeteers reveal themselves. They might hold up the characters they were playing and the audience might be invited to come close to inspect them.

POSTSCRIPT
Going Forward

Hopefully, the ideas in this book, as in other books by teachers who have creative ideas or adapted the ideas of others, will lead you to go forward with innovations of your own. If you use the projects with students, this will happen, for students cannot help themselves from going off a beaten path. Doing it differently seems a credo of the young and this is a good thing when it comes to art. The same spirit of innovation should prevail if you are embarking on the projects alone or as a parent with your kids.

As you will have discovered, the book is not so much step-by-step in its approach to creating the projects as it is a guidance operation, presenting a diverse sampling of illustrations to give you ideas. A hop, skip and a jump would be a better description of the processes described. This is because the processes are intended to produce very unique end products, and creations, hopefully, will be hop, skip, and jumping all over the place.

So, enjoy the excursion and don't get too frustrated if a project eludes you. Remember that you will do better with some projects than with others because you have an affinity with the materials or more motivation or more expertise. Ultimately, being creative has its own rewards: it encourages you to be alert to the sights, sounds, smells and textures around you; to relish nature; to sharpen your respect for the man-made and woman-made world; to perceive human nature more keenly, and best of all, to better understand and appreciate yourself through the remarkable things you alone were able to produce.

LIST OF ILLUSTRATIONS AND IDENTIFIED CREDITS

In the event that uncredited art works become identified, credit will appear in future printings.

Cover
Clockwise from top left:
Three Odd Fellows, puppets	Kevin Brennan (left puppet)
Tree and Button Flowers, fabric	Johanna O'Rourke
Jamaican Lady, folks in fabric	
Watering Can, movable object	Richele Lund

Strip-paper Designs
SP-1	Sailboat and Palm Trees	Jamie Himmelet
SP-2	Elegant House	Kathy Stussi
SP-3	Stately House	Sally Merrill
SP-4	Sunburst Flower	Beth Caruso
SP-5	Paper Tiger	Kristie Henry
SP-6	Mask	Stephanie Tatta
SP-7	Figure with Flowers	

Movables
M-1	Watering can	Richele Lund
M-2	Robin Redbreast	Sanna Lammetti
M-3	Stork	Paulette Gray
M-4	Stormy Sea	Erica Miranda
M-5	Umbrella	Jennifer Harvey
M-6	Clown	
M-7	Rabbit with Carrot	Patricia Coyle
MG-8	Cool Cat greeting card	Michelle Osciak
MG-9	Angry Kid notepaper	Lana Shuster

Movable Toys
MT-1	Rabbit with a Basket	Kelly O'Leary
MT-2	Elephant Rolling a Ball	Karen Kuchie
MT-3	Bear Balancing a Ball	Patricia Coyle
MT-4	Cartoon Character	
MT-5	Flying Bird	Matt Jacob
MT-6	Black Cat propped on clay with nail and cords	Alison Weber
MT-7	White Cow propped on clay with stick and cords	Jessica Zalme

Fabric
F-1	Multicolor Flower	Heather Terlecky
F-2	Purple Flowers	Andrea Kunst
F-3	Basket of Colored Eggs	Cara Augustine
F-4	House and Garden with Apple Tree	Teresa Metzger
F-5	Sunset and Birds Over Mountain Range	William Dorsett
F-6	Bedroom	Nanci Tetell
F-7	Sand Beach and Windy Sunset	Renee Charles

About the Author

Dr. Peck is a sculptor and college professor dedicated to sharing multi-media ideas with students and teachers. Her books are designed to help readers achieve the goal of realizing their creative potential while keeping aesthetic understanding at a high level.

Judith is a professional member of the American Art Therapy Association. In addition to school and home environments, the projects in this text have been successfully used with adults and children in therapeutic situations through Dr. Peck's 30-year program at Ramapo College titled, Art & Interaction. The diversity of materials and processes engages mental, emotional and expressive responses and selected projects can be successfully used in jails, mental hospitals, homes for abused children, battered women's shelters, urban housing projects and facilities for hospitalized veterans and the elderly.